Design Classics

Elke Tr

The

by Kl .ick

and Werner Sauer

Verlag form

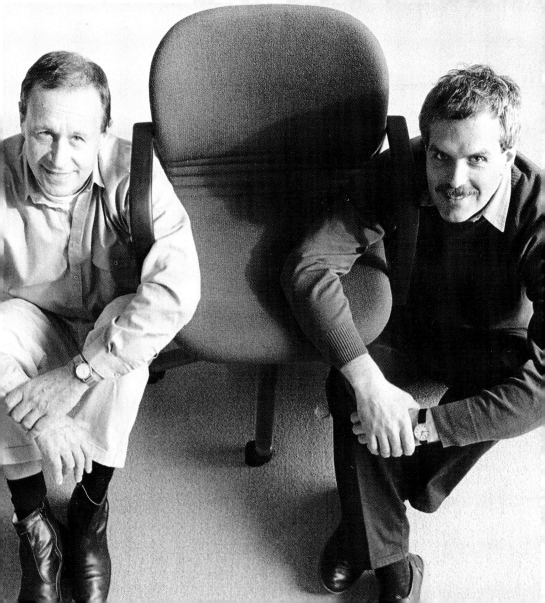

FS -Line: You've never heard of it or seen it? And certainly not on the classics floor? The first assumption is rather unlikely: since its premiere in 1980 at the *Orgatechnik* office furniture fair in Cologne, where *FS* was the theme, the manufacturer Wilkhahn has not only received design awards for this chair program from Hanover to Tokyo, but has also sold – would you believe it – 1.7 million copies worldwide, and to the finest addresses, at that. The second assumption, however, may still apply; although this chair fulfills all criteria ranging from innovation to durability with its "mature design" – criteria used by the classic among classic publications, the *Schöner Wohnen* issue on "Furniture that made history", to separate the commercial chaff from the cultural wheat [1] – *FS*, as a rule, does not appear in the popular classics repertoires of the magazines and book publishers.

A classic that isn't supposed to be one, or, at any rate, isn't perceived as one. Why? As the chair itself has no weak points, there is only one explanation for this inconsistency: the product genre is to blame. Because *FS* isn't just a chair but an office chair and, thus, at home in a "no man's land" that secretaries and bookkeepers wish to forget and suppress at five p.m. and designers and design historians would rather forget around the clock; one rare exception is the *Office* book by Elisabeth Pelegrin-Genel, which also contains an outline of office history. [2]

Contrary to this is a typical example that illustrates the general situation: the recently published chair appraisal by Charlotte and Peter Fiell covering a good one and a half centuries. In it, 1000 chairs are presented, but only 33 of them are office chairs. [3] This is an egregious misjudgment of the whole genre, and it is hardly surprising that the first operation-free chair with a synchronized mechanism, which transformed the armament of the work chair – a complicated sitting machine rigged with lots of control levers, wheels and knobs – back to a natural human scale, does not appear in the assessment. The chair was called *FS*, named for its two designers, Klaus Franck and Werner Sauer. It's a chair that has made history. One decade after its premiere, Wilkhahn proudly stated that *FS* had become "an example for a new generation of office chairs throughout the world." [4] Even if the synchronized mechanism, which adjusts the position of the seat and backrest not only to conform to diverse postures but also to flexibly accommodate the movements of a person, is still the exception today, the time of the mechanized monsters

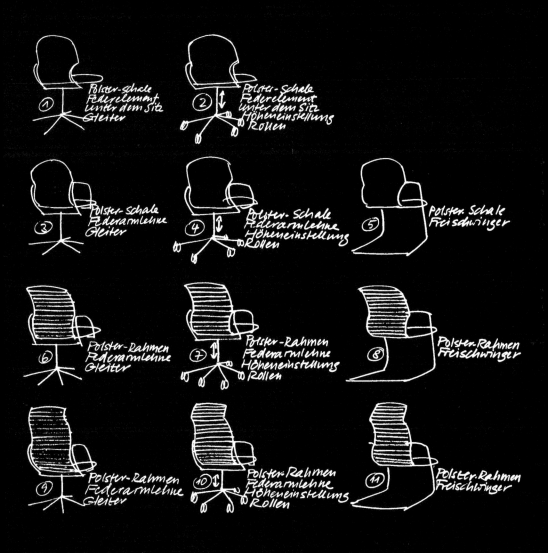

1. Polster-Schale
 Federelement
 unter dem Sitz
 Gleiter

2. Polster-Schale
 Federelement
 unter dem Sitz
 Höheneinstellung
 Rollen

3. Polster-Schale
 Federarmlehne
 Gleiter

4. Polster-Schale
 Federarmlehne
 Höheneinstellung
 Rollen

5. Polster-Schale
 Freischwinger

6. Polster-Rahmen
 Federarmlehne
 Gleiter

7. Polster-Rahmen
 Federarmlehne
 Höheneinstellung
 Rollen

8. Polster-Rahmen
 Freischwinger

9. Polster-Rahmen
 Federarmlehne
 Gleiter

10. Polster-Rahmen
 Federarmlehne
 Höheneinstellung
 Rollen

11. Polster-Rahmen
 Freischwinger

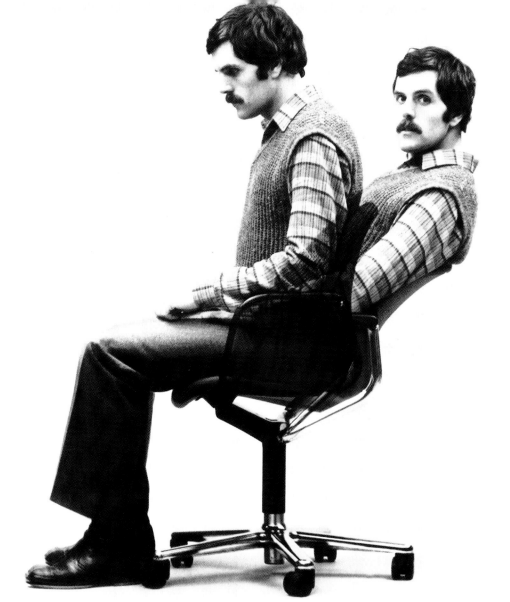

with the bulky pouch beneath the seat and the time of touting absurd and exaggerated promises of performance in the pursuit of new clients has irrevocably ended. At any rate, it couldn't defy the insights based on highly personal experience and long ago scientifically proven that man is "not made for sitting" and that "regular, extended sitting is damaging to our health." [5] And the statistics confirm this: of the 12 million German office employees who supposedly spend 80.000 hours of their lives sitting, there are 3 million sick leaves per year, and problems with the spine and bones take second place, just behind the common cold [6] – not to mention other typical damages resulting from permanent sitting, such as circulatory or metabolic problems.

Werner Sauer demonstrates the enormous flexibility of the innovative one-piece plastic seat shell in a two-phase illustration of the work and relaxation posture.

As we can learn from every magazine story reporting the office of the future, there is only one remedy: exercise and movement – for example, changing between desk and lectern. It's too bad that the general office equipment does not (yet) account for this and that electronic networking points instead in the opposite direction: like the rabbit paralyzed in front of the snake, the brainworker is sitting in front of his know-all and do-all PC. Ergo: if there is no movement in everyday office life, then at least a "dynamic sitting" should be possible because "a chair that moves is better than one that is rigid." (Sauer)

According to the cultural historian (and sitting critic) Hajo Eickhoff, [7] sitting on devices such as stools and chairs is a relatively young (only for the past 5000 years) habit in the history of mankind; it is not even common in all cultures and was established astonishingly late in the history

of the Occident. Even Walther von der Vogelweide's contemporaries didn't sit in a way that was much different from the nomads: "Kneeling and crouching and sitting on the floor with bent legs represent the customary physical posture during the Middle Ages."[8] The chair civilization began in the Occident only in the 16th century, i.e., the establishment of the chair as a basic piece of furniture for everybody. And with the began interactive formation of man and machine that, according to Eickhoff, transformed man from *Homo sapiens* into *Homo sedentarius* and, finally, into the passive *Homo sedativus*, which led him to work out ever newer, more comfortable chairs at a breath-taking pace.

The consequences: there is hardly another object that plays a more prominent role in design as the chair. Every furniture fair stresses this point with mass, every design history emphasizes it with class, and the normal daily life underscores this point with a profusion of genres, as though sitting had meanwhile become the generic term for a vast number of special disciplines: kitchen chair, office chair, dentist's chair, folding chair, deck chair, beach chair, rocking chair, high chair, armchair, wing chair; car seat and wheel chair, airplane seat and ejector seat...

Of course, as soon as the question of idealistic veneration comes about, the functional differentiation is all but forgotten. What counts even more is the aesthetic and social function of differentiation, which led Ettore Sottsass to ironically state: "The chair, in a communicative sense, must be a very important object." [9] From Thonet's bent-

The first schematic sketches still don't hint at the later form of the *FS* chair. They are typical for the design method of Franck/Sauer: in the beginning there wasn't a design vision but rather the factual research of the functional and constructive aspects. The simple line drawings on the bottom left, for example, play through the alternative constructive connections between frame and seat – either central or lateral.

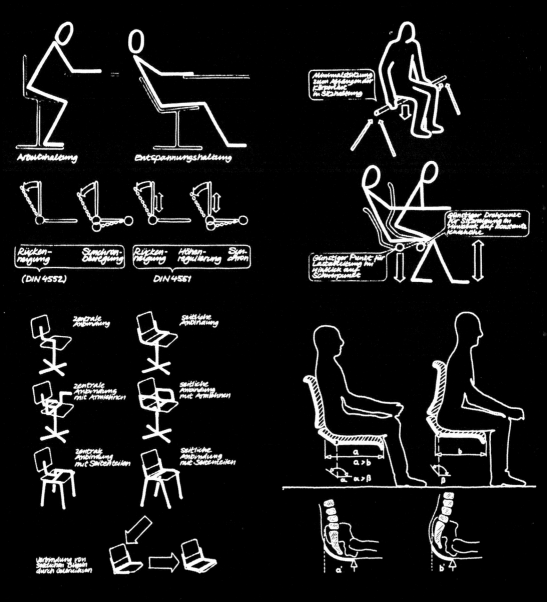

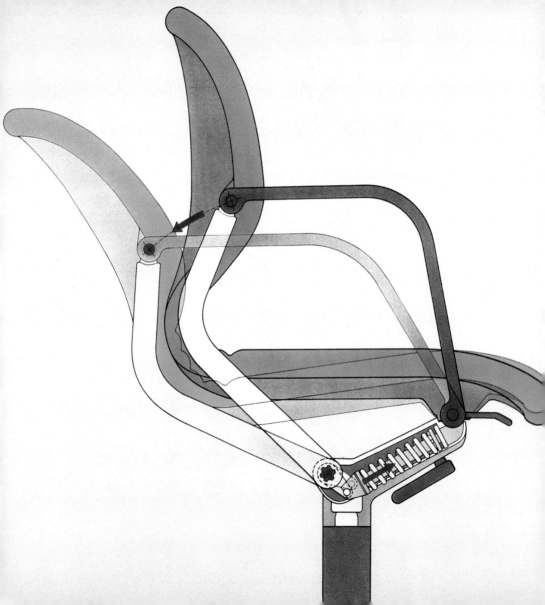

wood coffee house chair No. 14 (1859), to Marcel Breuer's tubular steel constructions of the twenties, and from Charles Eames' organically molded sitting shells of the forties and Verner Panton's – in a double sense of the word – fully sculptural sitting sculptures of the sixties, to Jasper Morrison's post-modern rediscovery of the chair itself (*Plywood Chair*, 1989), over and again designers felt challenged to "re-invent" the chair in the spirit of their time. And over and again they succeeded in creating masterpieces that were more than just comfortable and beautiful seats or, at least, that meant more. Chairs advanced to be culturally historic icons in which the style and lifestyle of an epoch condensed more poignantly than in most other functional and utilitarian objects, no matter how unavoidable they may be as milestones of technological progress.

From rocking chair to sitting machine

Things are quite different when it comes to office chairs. A hermaphroditic object, half furniture, half instrument, they have their very own tradition. It is the history of the mechanical chair or the chair as a sitting machine. As Siegfried Giedion, one of the few fans of this type of furniture, proved, [10] this history began considerably later than did office work itself (in the beginning of which, in our culture, were the orderly rooms of the medieval monks and the merchants' clerks) but earlier than the industrialization of office work, which started with the distribution of the *Remington* typewriter in the late eighteen-seventies. Giedion found early predecessors of the office chair,

In the mid-19th century, a mix between swivel and rocking chair had already been developed in the U.S., but only for private use at first. The specific American "casual and springing way of sitting" (S. Giedion) still finds its expression in the 20th century in the *Jasper Chair* 980 with its rocking mechanism placed beneath the seat – the famous successful model of the Jasper Seating Comp., founded in 1920, that is widespread in American courts and libraries.

A colored technical drawing clarifies the construction and flexibility of the synchronized mechanism. With the change of the sitting position, the angle between the seat and backrest is also automatically changed, i.e., opened.

Shown already in the model catalog from 1873 and offered well into the 20th century: Thonet's swivel fauteuil no. 1 (model 5501). The swivel leg transforms a normal armchair into an office chair. Greater care was given to the quality of the leg than to the work-appropriate design of the seat. As a lot of work was done at lecterns during the 19th century, these work chairs were available in three different heights.

One of many test models at a 1:1 scale. This one was for testing the torsion spring and the seat shell that is strongly bulged at the bend zone.

already provided with a flexible backrest, in a French desk chair dating from around 1730 on one hand, [11] and in an American swivel-rocking chair on the other, patented in 1853, mounted on a central leg with runners beneath the seat that allowed for a new form of "springy" sitting. [12] An engineered design typical for the 19th century, which, by the way, had not been invented for drudgery – similar to Eames' aluminum chairs 100 years later (originally called "Leisure Group") – but rather for leisure; one could say it was a mechanized rocking chair. Hence, our office chair evolved through a "cross" between the swivel chair and the rocking chair, which may come as a surprise to some. [13]

What had started in the 18th century with uninhibited scientific methodology – the refitting of the rigid carpenter's furniture into a physiologically reactive engineer's machine – ended in a Janus-headed utilitarianism by the end of the 19th century, in rhythmic step with the technical mechanization and rationalization of office work through the typewriter, calculator and telephone. The comfort of the chair as a work instrument soon served only to manifest the instrumentation of man into an efficient factor of production, following the motto: the less energy wasted in uncomfortable working posture, the more energy will flow into work performance. The standard chair recipe: a central support with at least three leg extensions, a height-adjustable wooden seat, vertical element with height-adjustable board to support the spine. At first, especially designed for the posture of the typist – the male officers had a more or less common fauteuil with a central leg – the typewriter chair marks the sad end of all seat inventions at

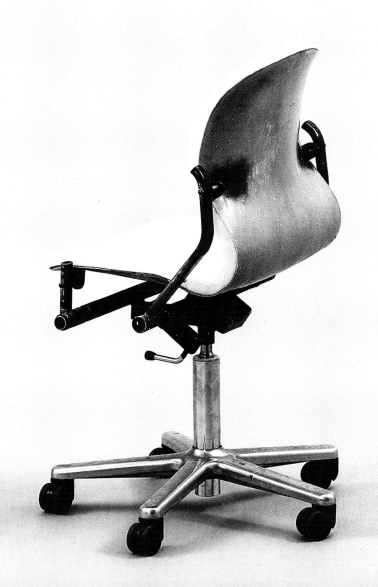

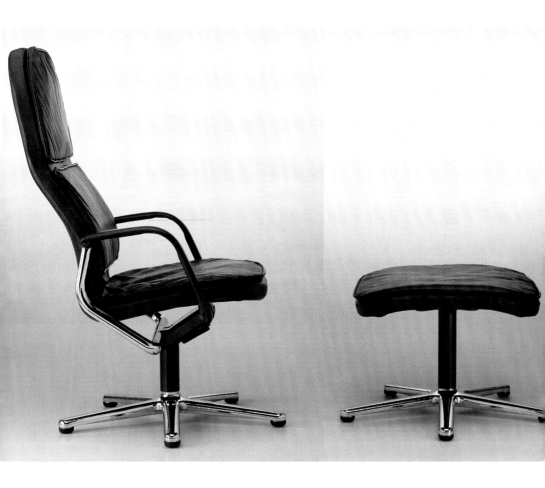

the end of the 19th century. But this couldn't stop the idea from spreading. With hardly any changes, this type served the rapidly growing new class of employees during the time immediately following World War II without designers or engineers wasting even the smallest spark of imagination for making it better or nicer. An anonymous product for the anonymous masses, its image was exactly appropriate to that of the office world: the incarnation of a dusty bureaucracy, unproductive salaried servants and a narrow-minded rank and pecking order – it can still be seen today in a hierarchical structure (internally: strictly followed, externally: simply laughed at) from the basic model to the proverbial executive's chair. Similar to Frank Lloyd Wright, who perceived the administrative building of Larkin Company built in 1904 as an overall work of art and who also designed the swivel chairs with wicker seats, and even a swivel chair connected to the desk [14], designers and architects have otherwise not dealt with this banal cousin of their favorite object, the chair. Even the machine-enthusiastic functionalists of the twenties were content to express their technological and progressive euphoria in a bland material aesthetic, preferably with tubular steel, and in traditional types – remember Marcel Breuer's *Wassily* chair, often called a sitting machine.

It was only during the fifties that the office advanced to the point of becoming an "object of study." [15] And, with its many appliances, it became interesting to the designers, who then finally began to enthusiastically involve themselves in the industrial production and innovation processes.

The *FS* top model 218/61 with the foot stool 219/31: an attempt to establish the black leather comfort chair also as a lounge chair. Although the transplant from the private to the office realm succeeded with Charles Eames' aluminum group, the reverse – the "domestication" of the office chair – didn't work in this case; the ottoman has disappeared from the program.

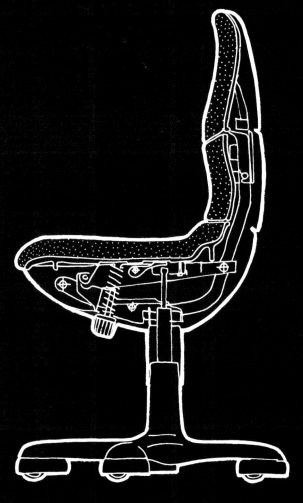

"Ergomat 190"
(Mauser)

verschalte
Synchronmechanik

In 1950 (the year when Olivetti launched Marcello Nizzoli's *Lettera*, the first commonly accepted "designer typewriter") a conference took place in Cambridge during which a key term for the future design of the work world is said to have been invented: it was derived from the Greek words *ergon* (work, performance) and *nomos* (law, rule). [16] As a new, specialized discipline of work-related science, in charge of the adaptation of the workplace to the human organism, ergonomics would soon spread like a magic spell – this time not only with a Taylorist view of the optimization of human performance but also under the designation: "humanization" of the workplace. The ergonomics-euphoria reached its dubious climax during the seventies (at least in Germany). And its favorite object was the office chair. And as the bureaucracies, i.e., the German Institute for Standardization (DIN) founded in 1973, quickly translated the new awareness into regulations, ergonomics caused the chair market to begin moving forward economically.

Ergomat 190 by Mauser: a typical example of the sitting machines of the ergonomics-craze of the seventies that concealed a plethora of mechanical complexities in the bulgy chassis beneath the seat. During the *FS* chair conception, they were omnipresent as a negative example. Optimal function with a minimum of operation and an uncompromising unity of form and function were the goal.

Functionalism in its purest form

FS also had the precondition of this ergo-economic dynamism. At the same time, though, it was in sharp contradiction to all the side effects that such a panacea usually manifests when it is carried onto the market. It wasn't enough that the manufacturers now offered every "office rat" what was his or her right according to DIN 4551 (for example, an adjustable seat height between 42 and 50 cm, height-adjustable backrest between 18 and 25 cm, a seat depth between 48 and 42 cm [17] as well as

In 1974, Drabert recommended the ergonomic top performer typical for its time, the *Relax-o-flex-chair* (design: D-Team-Design) with a height-adjustable backrest as "an office chair designed on the basis of scientific research." In today's office chair generation, the one-piece backrest is dominating, and the height adjustability no longer plays a role – as was the case already in 1980 for the *FS*.

Four different upholstery variations and yet unmistakably *FS*: "Permeation of the product system with coherently designed, visible functional elements" was one of the preconditions during the development of the *FS* Line.

a five star base), but they also started to mutually outdo each other, exceeding the DIN requirements. Office chair design was completely swept away by the gadget mania criticized by the American psychologist Donald A. Norman a few years ago as "the plague of performance characteristics." [18] Illustrative of this is a controversy documented in the German design magazine *form* from 1974: indignantly, the ergonomist Ulrich Burandt protested against the supposed scientific approach with which two chair novelties were presented like the ultimate solution (an increase of 40% in terms of work performance was even being promised). One of them was a hybrid seat with four adjustment levers for six different functional controls. [19] With names like *Ergo-Style* (published by Drabert), ergonomics finally reached the level of suggestive marketing. [20]

Everybody who has played around with this lever and that wheel knows how absurd it was to assume that the customization should be left up to the user: the mechanical adjustments can't be understood. What is even more absurd: many users capitulated from the outset. "A technique that is difficult to handle is generally ignored," [21] stated Burandt in 1978 in his study for Wilkhahn called *Foundations of Sitting*. His summary: many adjustment devices are superfluous; tests on the synchronized coupling of seat and backrest "in practice met with approval", but have not yet been "examined closely." [22]

That same year, the Wilkhahn designers Klaus Franck and Werner Sauer began with the *FS* development. It was based on the findings of the ergonomists (above all Etienne Grandjean and Ulrich Burandt) and was further-

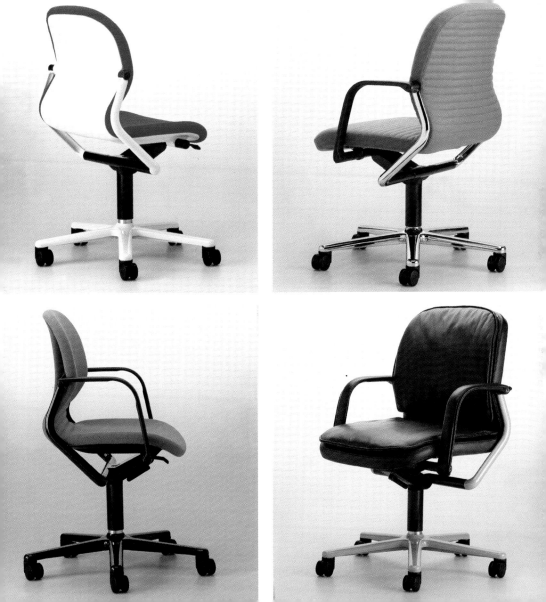

Wilkhahn sitzt. So oder so.

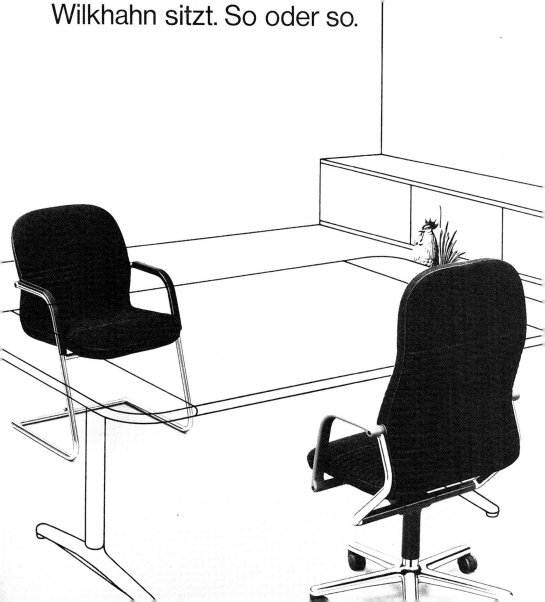

more provided with the know-how gained from the preceding Wilkhahn chair developments (the futuristic model 237 by Delta Design that already had a synchronized mechanism and was given the nickname "DIN-chair", and the chair 190 by PER Roericht/Fleischmann, should both be mentioned). And last but not least, ascribing to a design approach with the leitmotif "function, aesthetics, technology," Franck emphasized that "function is first and foremost". "Following the procedure, still favored today, whereby a company buys the finished mechanism and then adds its own design" was never a temptation for Wilkhahn and its designers – no more so than the artistically expressive design approach with which the avant-gardists of *Alchimia* (founded 1976) and *Memphis* (premiere in 1981) rang in Post-Modernism in design at around the same time. As far removed from fashionable styling as from individualistic art, the *FS* chair represents exactly what the avant-garde were attacking back then: functionalism in its purest form.

Thus, *FS* has not only made history as the first foolproof, operation-free office chair with synchronized automation – this is what led Wilkhahn to the poignant slogan "Sitting without a driver's license" – but *FS* is also a perfect example for design according to the much-quoted Sullivan dictum "form follows function." And it is a living counterargument to the thesis which states that the primacy of function happens only at the cost of aesthetic expression. At first glance, two main characteristics distinguish the chair from its peers, and they are both based on function and construction. The accentuated curvature provides the polypropylene-seat shell with the flexibility necessary for

Wilkhahn advertisement from 1983. The image – *FS* models in an abstract space that leads us to imagine a typical situation – underlines, as briefly and obviously as the slogan "Wilkhahn sits. In any way," the message: manager chair here, visitor's chair there – there's no difference in the quality of sitting Period.

With *Aeron* and its crude machine aura, the two American designers William Stumpf and Don Chadwick created a spectacular revival of the "sitting machine." Marketed in 1992 by Herman Miller, the conceptually, technically and aesthetically unusual chair that needed some getting used to was met with heated controversy by the specialists in 1994 at Germany's *Orgatech*.

A look beneath the seat reveals what Wilkhahn meant with the fresh slogan "Sitting without a Driver's License": the only operating element is a turning disc with which the resistance of the backrest is controlled via the double coil spring – one for pre-adjustment, one for the individual fine tuning.

the angle between seat and backrest to open up if one leans back. And the swing arms connects the seat shell with the forward seataxis of the supporting frame and with the double spring mechanism mounted beneath the seat – more concretely: it transfers the spring force and thus controls the resistance of the flexible backrest so that it will yield either harder or more softly depending on the adjustment and, as soon as there is no load, automatically returns to the neutral position.

There is also a functional reason for the fact that the designers decided on the swing arms, i.e., for a lateral connection of the seat to the underframe (as opposed to most swivel chairs, where the backrest and armrests are added on from the center of the support frame), although it is now unrelated to the physicality of the owner but rather to the corporate marketing strategy. When Wilkhahn considered the development of a new office chair program at the end of the seventies, they not only wished for a new piece of furniture but also a so-called product line "with a coherent design language" (Sauer) for all uses and versions – from the doorman's chair to the executive's and from the worker's chair to the visitor's and conference chair. Hence, since four-legged versions and cantilever chairs alike should be part of this family, from the beginning the designers found a construction with a lateral connection more "logical", says Franck.

Over two years would pass before the complicated harmonization of form and function was finally achieved, for which the Wilkhahn advertisements liked using the paradoxical slogan "First Form. First Function". Design – in

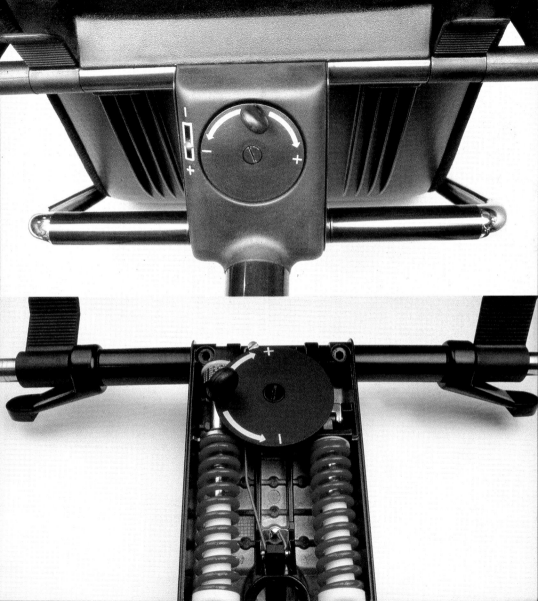

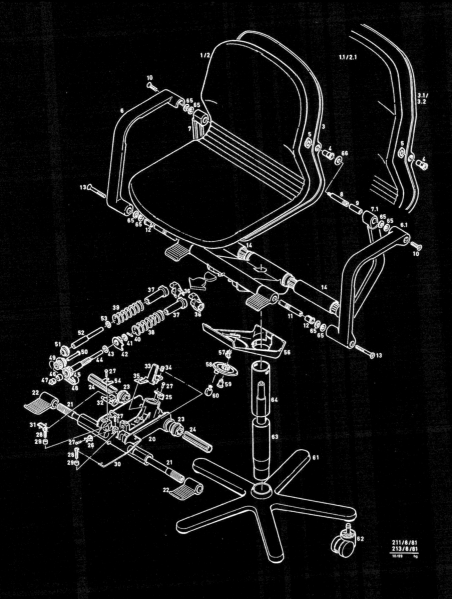

the case of *FS*, this also means: not just object design, but also interdisciplinary product development in the sense of the legendary Ulm University for Design (HfG Ulm, 1953-1968), where the tradition of the Bauhaus was continued in a contemporary manner after the war. Indeed, (almost) all paths to *FS* lead through Ulm. And this not only applies to the two designers Franck and Sauer but also to the Wilkhahn entrepreneur Fritz Hahne.

Greetings from Ulm

It was Hahne (born 1920) who made the wood chair factory Wilkening and Hahne – founded in 1907 by the carpenters Friedrich Hahne and Christian Wilkening and a typical business for the region with its beech forests – into one of Germany's leading "design companies" (next to Braun, Erco, Lamy, Rosenthal) after the war and, finally, during the seventies, into an office furniture company with global distribution and international reputation. [23] For years, the entrepreneurial spiritus rector and the designers worked together closely beneath the company's roof in Eimbeckhausen (Bad Münder) near Hanover; their collaboration was based on the same design essentials: "We endeavour to create products that are thought through, innovative and of long term validity and which may be regarded as a contribution to the culture of our time." [24]

Hahne, who ascribes to himself a passionate "tendency towards the new, and activities with a spiritual background", [25] had already found initiators, trailblazers and guarantors for his entrepreneurial maxim "truthfulness in design" during the fifties in Ulm: at first in Georg Leowald

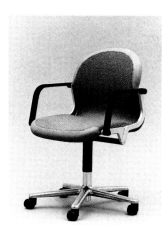

One of the last (and rejected) design studies in the *FS* development: instead of the boomerang-like swing arm that would in the end become its trademark, it shows the attempt to formally harmonize the connection of the frame and shell with a crescent-shaped element.

A so-called "explosion drawing" of the *FS* chair. The drawing that demonstrates all parts and their constructive arrangement serves as a manufacturing manual.

and Wilhelm Ritz, and then in the Delta designers Michael Conrad, Henner Werner and Detlef Unger, in Nick (Hans) Roericht and Herbert Ohl, and finally, also in the graphic designers Tomas Gonda, Rolf Müller and Bernd Franck, who created the irreproachable and fresh corporate image of the company – hardly altered to this day – during the sixties.

Klaus Franck (born 1932) is also a true "Ulmer", almost one from the first hour. After architectural studies in Braunschweig, he went to the University for Design in 1955 and finished his studies – interrupted by a scholarship in Brazil – receiving his degree in 1959. His first professional positions were still clearly characterized by an affinity towards architecture: three years of collaboration in the Institute for Industrial Architecture of Herbert Ohl, the last director of the university; freelance work as a book author and designer (among others, a Hatje-volume on exhibition design); 1962 to 1970 finally head of interiors with Deutsche Lufthansa, where he was in charge of the conception and design of city offices, exhibition environments and stands. After a short interlude with Vitra, he joined Wilkhahn in 1972 as the first employed designer – this marked the beginning of a 21-year-long commitment. He sketched his tasks as head of the soon expanded in-house design department (spun off in 1985 under the name "Wiege" – Wilkhahn development division) as follows: "Coordination of the designs by the freelance designers, establishing and maintaining connections, correct and develop designs". It was a mixture of design management, mentorship and an anonymous product development aid for his colleagues. It was impossible to realize his own

The entrepreneur Fritz Hahne understands architecture as "a piece of responsibility for the future." The light pavilions by Frei Otto, which have housed the upholsterers since 1988, are one of the best examples for Wilkhahn's synthesis of corporate culture and architecture.

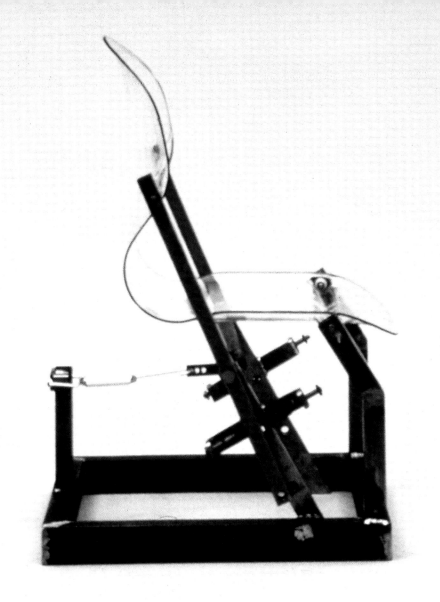

designs. Wilkhahn worked exclusively with external designers – until the *FS* program came about. The only original product design of the early years by Franck, who soon was also responsible for the corporate graphics, is the standard five star base, still used to this day, for the office swivel chairs from the mid-seventies.

The designer as an assistant, more dedicated to the task than to self-realization – this also was the perspective with which young Werner Sauer started his Wilkhahn-career. After his design studies oriented towards industrial professionalism with the part-time "Ulmer" Stefan Lengyel in Essen (diploma 1974) and a secondary course of studies at the new interdisciplinary department "Experimental Environmental Design" in Braunschweig (diploma 1977 with a thesis on new forms of living and participation – a theme that occupied the progressive minds during the seventies as strongly as did the industrialization of building during the sixties), he had first come to Eimbeckhausen as a project collaborator in the realization of Herbert Ohl's *O-chair*, a new construction consisting of a three-dimensionally shaped aluminum frame and an elastic polyester net. He accepted the offer to join the Wilkhahn design department because the way that design was practiced there met with his intentions: "I've always been interested in products that are complex". The fact that he could only move things "in the sense of the external designers" was no more frustrating to him than it was to Franck – they both attest to this. Generally, it seems that two related minds in terms of design approach ("We are not purists of the form", says Franck) and in temper (calm, concentrated)

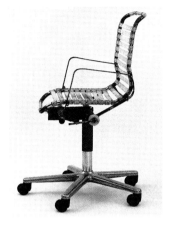

Before the formal detailing took place, different functional models were created to test the practical value of the theoretical insights about "dynamic sitting". With this model from 1979, the spring armrest was being tested.

A flexible frame with a seat shell served as a testing device for determining the precise movements and the distribution of the loads.

29

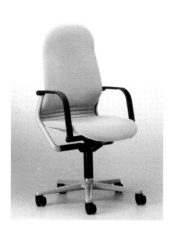

A must for an office chair program that wants to succeed on the market: the subtly differentiated range in the equipment that is to pay tribute to the office hierarchy. This picture shows an *FS* version for the higher employee, noticeable in the high backrest.

An unusually talkative intermezzo: Wilkhahn advertisement from the early nineties. In the meantime, they returned to a pointed interaction between the picture of the product and a succinct slogan.

had come together. The collaboration in the first internal Wilkhahn product, the new *FS* development, turned into a permanent partnership that also is successful on a freelance level. Franck left Wilkhahn in 1992 and went into active retirement; Sauer left the company years later to teach product design at Hildesheim University. Since *FS*, their list of works is quite remarkable: under the Wilkhahn logo it includes the *Uno* desk (1982), the seminar table program *Thema* (1986), the chairs *Lamina* (1984) and *Versal* (1990), the upholstery furniture program *Cubis* (1990), the *Basis* bench systems (1983) and *Tubis* (1991, first used in the new Munich airport and recently in Hongkong's mega-airport), the elegant office chair program *Modus* (1994); and add to this the extremely variable desking program *x-act* for *Planmöbel* (1996), with which – according to the saxophone player and Jazz-fan Franck – everybody can arrange their workspace as well as the drummer can arrange his instrument. Currently the next product for Wilkhahn, still a secret, is in the works.

From hard-working anonymous to star-designer – this isn't your classical designer career. Yet, if one recapitulates the story of *FS*, one must bid farewell to some of the clichés used to describe the of late oh-so-glamorous beatific design, anyway. Great visions, beautiful drawings, ingenious appearances on the management floors – forget it. The *FS* product development happened in a different way – completely different. What is most astonishing to outsiders is that "At first, it was completely open how the chair should look". (Franck) Only after they had found the functional constructive alpha and omega, the position of

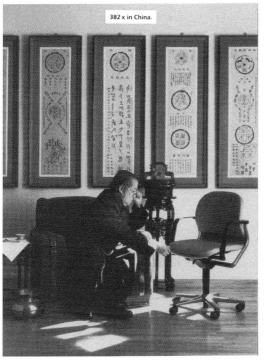

382 x in China.

Als das Riesenreich China nach den Jahrzehnten der Kulturrevolution und der in sich gekehrten Betrachtungsweise seinen Blick gen Westen wandte, entdeckte es da Dinge, die durchaus nützlich sein konnten: Zum Beispiel den westlichen Bürostuhl als wesentliches Hilfsmittel des im Sitzen arbeitenden Teiles der Bevölkerung.

So kam es, daß schon 1985 die ersten unserer Bürostühle nach China kamen, um dort ihren Platz einzunehmen. Nicht als chromglänzende Symbole des gesunden Kapitalismus, sondern als schnörkellose Vertreter für gutes Sitzen.

Und als solche scheinen sie ihre Sache sehr gut gemacht zu haben: Heute, sechs Jahre später, versehen schon ein paar hundert von ihnen ihren Dienst im fernen China.

Das mag zwar angesichts von über einer Milliarde Einwohnern nicht viel sein, aber: Immerhin. Der Anfang ist gemacht. Und es ist eigentlich immer mehr daraus geworden.

Tochtergesellschaften zum Beispiel. In Österreich, in der Schweiz, in Spanien, Frankreich, England und sogar in Japan mit seinen so ganz anderen Sichtweisen und Sitzgewohnheiten. Oder Partnerschaften auf Lizenzebene. Wie in den USA. Oder in Australien,

Über 600.000mal in aller Welt. Die FS-Linie von Klaus Franck und Werner Sauer.

wo wir – in aller Bescheidenheit – die Nummer 1 im Markt sind. Und das vielleicht auch deshalb, weil auch hier so weit wie möglich mit landesüblichen Verfahren und Materialien gearbeitet wird. Wohlgemerkt, immer im Sinne des Erfinders.

Denn auch wenn ein asiatischer FS zwei Zentimeter kleiner ist als sein europäischer Bruder, auch wenn ein australischer FS die Wolle für seine Bezugsstoffe von australischen Schafen bezieht: FS bleibt FS. Multikulturell und überall gleich gut.

Das ist gut für ihn und für unsere 33 anderen Partner, die rund um die Welt für eine gesunde Haltung zur und bei der Arbeit stehen.

Und dafür, daß man ziemlich weit kommen kann, wenn man klein anfängt und weniger in großen Zahlen denkt. Sondern vielmehr erstmal daran, daß in allen Kulturen und Erdteilen der Welt die Hinterteile gleich sind. Und das gleiche wollen: Einfach gut sitzen.

Wenn Sie jetzt wissen wollen, wie und wo Sie mit uns sitzen und arbeiten können und welche Möglichkeiten es da im einzelnen gibt, dann rufen Sie uns doch mal an:
(0 50 42) 80 12 03.

Wilkhahn

Ob in Österreich (02 22) 8 94 21 66, in der Schweiz (0 31) 21 11 65 oder in 35 anderen Ländern: Wo immer Sie sitzen – wir sind nicht weit. Wilkhahn, D-3252 Bad Münder 2

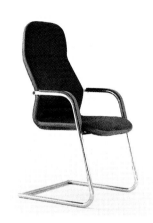

Although the *FS* Line was developed as an office chair, it was also to include various versions of a conference and visitor chair. They were designed as cantilever chairs. The seat shell provides the "family character." Above: the version with the high backrest from the 1980's.

the pivot points for the synchronized inclination of seat and backrest, they were faced, according to Sauer, "with the difficult question: how will we develop the design from this?" Because one thing was irrevocably clear: "We wanted to make the function visible in the appearance". (Sauer) In a booklet where the designers put down in writing their first principles for the development of a new chair program, they write explicitly: "constructive goal: innovative and intelligent solution of the functional requirements". And the formal guideline reads: "pervasion of the overall product with coherently designed, visible functional elements" – a requirement that was to have far-reaching constructive consequences in the course of the development.

The furthest-reaching consequence came about only after the chair had already been designed: the total change of the mechanism. Even during the Cologne premiere, the *FS* was available only with armrests, and for good reason. The armrest contained a spring steel insert that provided the counter-pressure for the backrest. The further the backrest was inclined toward the back, the wider the angle of the steel spring, which had one pivot in the front beneath the seat cover and the second directly above the bow on the back. A mechanical chair without a special mechanism – this original, simple and intelligent idea was even patented. Unfortunately, it only partially conformed with the standards. The DIN-regulation of the adjustment of the backrest resistance to the body's weight was fulfilled by this spring in the broad average range, but at the extremes, "the 50 kilos at one end of the range

and 100/110 kilos on the other were simply not feasible", as Sauer regrets.

Something else was required: in order to serve all levels of the office and chair hierarchy, Wilkhahn also needed the simplest version, a chair without armrests. This meant that a different mechanical solution needed to be found, and it was a twin coil spring beneath the seat. As a consequence, this coil spring was then installed in all models. The armrest still kept its functionally optimal form – shorter than usual, which allowed for the chair to be moved closer to the desk – but now it only followed the movements in a passive way. One can still detect a certain disappointment on the part of both designers; they had to bid farewell to the absolute form-function-technology equation and, thus, to the totally operation-free and class-free chair, and in the end, they had to fall back on a hidden mechanism. Although the mechanism hardly changed the appearance of the chair – it was conceived in such a way that it could be installed into an element that was there from the beginning, the connection between the central column and the seat cover. Any untrained eye unfamiliar with the complex construction of the chair would have to be guided towards the fact that the chairs pictured in the documentation *FS-Linie. Eine Idee wird zum Programm* (FS-Line. An idea becomes program), published by the end of the eighties, don't represent the final version. It would be best to have the designers themselves tell the story about all the know-how, skepticism, hard work and fantasy, routine and risk, self-assurance and control, that was necessary to solve this "classical task of indus-

The model with the regular backrest as it is produced to this day.

33

trial design" (Sauer). Until the product crystallized out of this idea, numerous development stages and confrontations with the peripheral fields, which, as designers, they first had to become familiar with, were necessary. Therefore we'll look only at the decisive way-stations along the path of this long and complicated development history.

Evolution of a chair

The introduction already indicates the thoroughness and pragmatism with which Franck and Sauer set out to accomplish the task. There are no chair designs and no construction drawings, but there are two diagrams about Wilkhahn's market position. One of the primary motives for the development of a new program was the enterprise's wish – they had secured the upper segment of the office market during the seventies – to expand its market share by targeting the lower and medium segments. The numbers were a known fact. The amazing result: after a thorough study of the material, Franck came to a completely different conclusion than did the management. According to it, the market – in terms of price – didn't represent itself in the form of a pyramid but rather in the form of an onion: the greatest volume was in the mid section. In the beginning of the real design work there stood systematic studies on the physique, postures and alternative chair constructions. The entire first phase of development was then concentrated upon the invention of a synchronized mechanism which, contrary to the already existing synchronized mechanisms, would force the chair to follow the movements of the user permanently and not only upon pushing some

Part of *FS* line's success story is the representative use in famous international institutions. In Santiago de Compostela, for example, the plenary hall of the Galician parliament was furnished with high backrest chairs from the manager chair type.

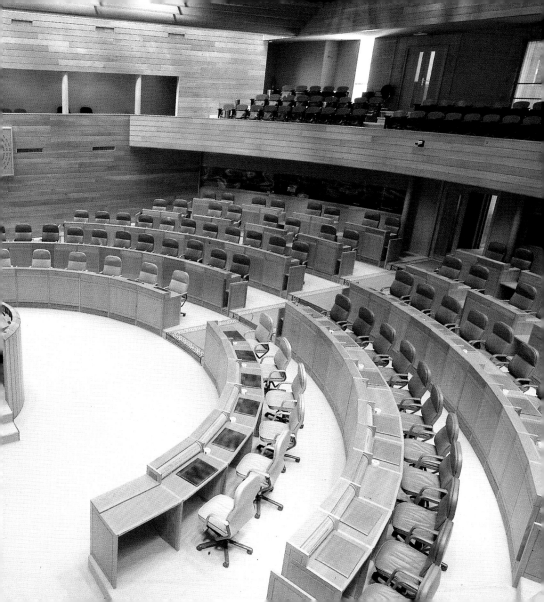

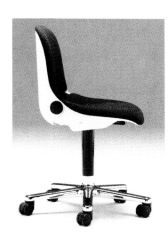

In 1970, with the repeatedly awarded swivel chair 232, designed by Wilhelm Ritz, "a new phase of proliferation" in the upper section of the office chair market began for Wilkhahn. They propagated the split shell work chair with the significant point on the pivot joint as "an office chair alternative for everybody for whom the office is more than just a work space".

button. The most important question was: where would the pivots be located through which the incline of seat and backrest (at an approximate ratio of 1:2 degrees) are controlled? With the help of uncountable sketches and models (so ugly, said Sauer, that they couldn't be shown to anyone), the designers finally learned that by positioning the central axis in relation to the front axis, in conjunction with a flexible seat/backshell, a virtual pivot point was defined, which corresponds to the position of the human hip joint. With this insight, the first hurdle was surmounted: the function was clear. Yet, there was still no sign of the form at this point.

The second development phase was marked by the innovative idea to create the seat from a single shell, flexible in the central zone. „Here, too, the thought was to integrate as much function into the form in every single component, and not to install an additional joint", says Sauer. The movement sequence and load distribution were finally tested with a life-size test model with a shell and various springs. From this, the spring armrest resulted, and only then did the swing arm following the shape of the backrest "evolve", as Sauer stated. And in the end the swing arm became the dominating characteristic of the chair in all its versions. Diverse attempts to match the shape of the backrest, like a sickle, to the curve of the shell were finally abandoned out of – as one might guess – principle. Sauer: "The sickle shape had one disadvantage: it concealed the function". It is due to their aesthetic sensibility that the swing arm continuously tapers, though minimally, from the bottom to the top by approximately four

millimeters. "Had we not tapered the diameter, the bow would have been plump and would actually have looked thicker on the top", says Sauer.

In the end, the designers "invented" a feature (also patented) for the upholstery, as they would do later in the case of the backrest of the *Modus* chair, which is stretched between two forks: The centerpiece of the foambody consists of a clip profile with steel inlay. The foambody is created through a moulding process around this inlay and clips easily onto the seatshell. This also makes changing the upholstery child's play. *FS* – a highly complex classical industrial design for which all design aspects were integrated in the development, from the functional concept up to the manufacturing technology. Certainly, the designers profited from the experience gained from their previous work for Wilkhahn. "Without the knowledge of the technology and material that we had acquired, we couldn't have made this product as well as we did", according to Sauer.

In the fall of 1980 *FS* was launched onto the market, and in the following year, the chair was already being delivered with the coil spring beneath the seat. However, the designers hadn't really finished this project, at all. "Over the years, we've technically changed almost all of the components. Of course, we took great care to preserve the form". (Sauer) The first optimization: the swing arm, a tube-like cast aluminum component, was given a bean-shaped cross section. Thus, the plastic cap that served as a protection against the inside ribs of the original bow became superfluous. The second optimization: in order to

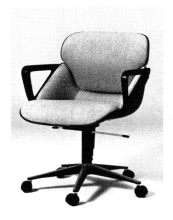

A predecessor for dynamic sitting with synchronized mechanism was the Wilkhahn program 190 with the three-piece seat shell made of fiberglass reinforced polyester, design PER, Roericht/ Fleischmann, 1976. Of course, the mechanism functioned upon pushing a button and was "hidden" in the shell.

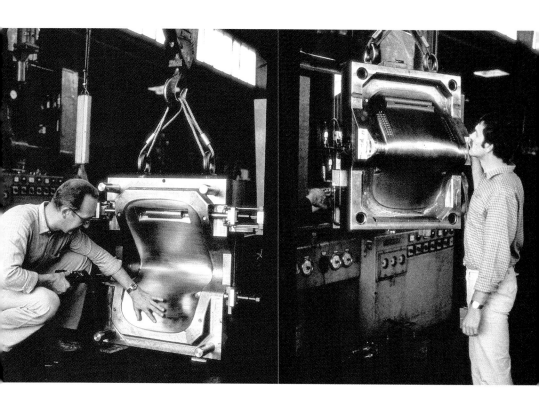

facilitate the backrest adjustment with the coil spring, a double spring was installed – one for the pre-tension and one for the individual fine adjustment. In the current models, the spring tension is no longer regulated via a lever. Instead, a disc is used, and a dial provides information about the degree of tension. The third optimization: after the spring steel had become superfluous, the armrest was manufactured entirely with polypropylene, and its design was slightly changed. "In order to work out the function of bending through the form" (Sauer) the bottom side today is slightly carved out in the angle zone. Finally, by the end of the eighties the chair with the round backrest was joined by a cousin with a square backrest, also offered in almost all versions. Meanwhile the "family" gathered around the original classic, model 211/8, has grown to an amazing 40 members.

Werner Sauer (right) in the production hall with the tool for pressing the highly flexible polypropylene shell. The single-piece shell was one of the most revolutionary (and patented) innovations of the *FS* Line.

FS – a complete design success – and economically, as well. With a single stroke, the novelty terminated the crisis that Wilkhahn faced during the seventies. [26] And what may have pleased the designers – no-names up to that point – especially: they have withstood the competition of two of the Greats in their guild with this masterpiece. Around 1978, Wilkhahn boss Fritz Hahne had almost bought the *Vertebra* chair by Emilio Ambasz and Giancarlo Piretti, which was already a completely developed project at that time. The deal finally fell through, according to Hahne, because of the "hefty" demands of the designers. [27] This was good luck for Wilkhahn, as well. In retrospect, the internal development not only proved to be functionally superior – a typical office chair and *Vertebra* weakness

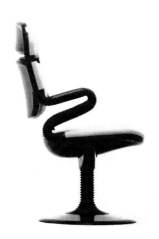

being, for example, the so-called "shirt-pull" effect, which occurs if the seat moves forward when one leans back. But also, from a commercial stand point the *FS* program has left the prominent rival far behind.

The ergonomics euphoria during the seventies has meanwhile changed to quite the opposite. Today, it is no longer the belief in the optimal chair that can remedy all ills but a deeply uncomfortable feeling about our favorite posture that marks the critical sitting awareness. It is symptomatic for the nineties that an exhibition like Hajo Eickhoff's *Sitting* in the Dresden Hygiene Museum in 1997/98, questioning sitting in all respects, becomes a success with the audience. Even the Wilkhahn advertisements mirror the new spirit of the times. With the same mixture of competence and humor that formerly produced slogans like "Sitting without a driver's license", today, skepticism and paradoxes are cleverly presented: "Sitting damages your health!?" "It's all a question of posture!?" "All chairs are equal!?" While permanent sitters, bothered by their own backs, are trying one seat-alternative after another – knee seats, standing seats (like Wilkhahn's *Stitz*), sitting balls (distributed by public healthcare) and even extremely overdone sitting machines (like Herman Miller's *Aeron*, design by Donald Chadwick and William Stumpf) – the *FS* still outdoes all ephemeral bearers of hope. Almost 20 years after its creation, it still functions as self-evidently as ever. Design: the high art that makes the reasonable feasible.

In 1977, Emilio Ambasz and Giancarlo Piretti developed the *Vertebra*, which is produced to date by Castelli (Italy) and Krueger (U.S.). The chair of the famous design duo was offered to Wilkhahn but rejected by the boss, Fritz Hahne, as being too expensive.

In 1983 the Wilkhahn advertisements were already placing the *FS* chair onto a level with the great furniture design classics in a self-conscious way: the Le Corbusier chaise longue, the Panton chair, and Rietveld's *Red and Blue Chair*. The following years confirmed the slogan "Only those who are ahead of their time can become classics. Thank God. " *FS* became a permanent bestseller.

Ein Klassiker werden kann nur,
wer seiner Zeit voraus ist. Gottseidank.

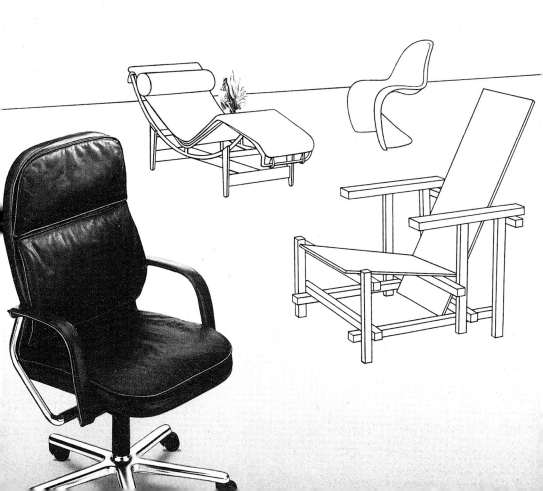

Notes

1 *Moderne Klassiker. Möbel, die Geschichte machen*. Publication of *Schöner Wohnen* magazine, 17th edition, Hamburg 1996. Foreword, p. 5.
2 Elisabeth Pelegrin-Genel: *Büro. Schönheit, Prestige, Phantasie*. Cologne 1996.
3 Charlotte and Peter Fiell: *1000 Chairs*. Cologne 1997.
4 Wilkhahn. *Dokumente der Gestaltung*. Bad Münder 1992, p. 39.
5 U. Burandt: *Grundlagen des Sitzens*. Study ordered by Wilkhahn. Bad Münder 1978, p. 5.
6 *DM*, November 1991, p. 81.
7 Hajo Eickhoff: *Himmelsthron und Schaukelstuhl*, Munich 1993.
8 Ibid., p. 151.
9 Hajo Eickhoff (ed.): *Sitzen. Eine Betrachtung der bestuhlten Gesellschaft*. Catalog for the exhibition of the same name in the German Hygiene Museum, Dresden 1997, p. 141.
10 Siegried Giedion: *Die Herrschaft der Mechanisierung. Ein Beitrag zur anonymen Geschichte*. Special edition Frankfurt 1987, pp. 440 onward.
11 Ibid., p. 445.
12 Ibid., p. 443.
13 Ibid.
14 Klaus-Jürgen Sembach/Gabriele Leuthäuser/Peter Gössel: *Möbeldesign des 20. Jahrhunderts*. Cologne, no year, p. 88.
15 Pelegrin-Genel, p. 62.
16 Christina Schwarzpaul in: *z.B. Stühle*, Giessen 1982, p. 44.
17 Burandt, p. 34.
18 Donald A. Norman: *Dinge des Alltags*. Frankfurt 1990, p. 203.
19 *form* 66, p. 44 and *form* 67, p. 38.
20 Catalogs if-Industrieform Hanover 1978, 1979 and 1980.
21 Burandt, p. 37.
22 Ibid.
23 According to their own statement, Wilkhahn today has 520 employees in Eimbeckhausen, and approx. 600 specialist dealers and licensees worldwide
24 Wilkhahn. *Dokumente der Gestaltung*, p. 8.
25 Fritz Hahne: *Zwischen den Stühlen*. Bad Münder 1990, p. 107.
26 Ibid., p. 11.
27 Ibid., p. 117 onward.

Bibliography

100 Masterpieces aus der Sammlung des Vitra Design Museums. Ed. by Alexander von Vegesack, Basel 1996
Burandt, Prof. U.: *Grundlagen des Sitzens*. Study ordered by Wilkhahn, Bad Münder 1978
Eickhoff, Hajo: *Himmelsthron und Schaukelstuhl. Die Geschichte des Sitzens*. Munich, Vienna 1993
Eickhoff, Hajo (ed.): *Sitzen. Eine Betrachtung der bestuhlten Gesellschaft*. Catalog for the exhibition of the same name in the German Hygiene Museum, Dresden 1997
Fiell, Charlotte and Peter: *1000 Chairs*. Cologne 1997

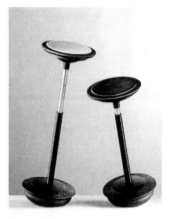

The insight that sitting is hazardous to your health and that working at a lectern is healthier caused Wilkhahn to create a playful allusion. In 1991 the movable standing support *Stitz*, designed by Nick (Hans) Roericht was launched onto the market.

14 years after the introduction of the *FS* Line, the designers Klaus Franck and Werner Sauer designed a competition for their own design at Wilkhahn: the elegant *Modus* office swivel chair (1994) again became an instant market success.

Giedion, Siegfried: *Die Herrschaft der Mechanisierung. Ein Beitrag zur anonymen Geschichte*. With an epilogue by Stanislaus von Moos. Edited by Henning Ritter. Special edition Frankfurt 1987
Grandjean, Etienne: *Physiologische Arbeitsgestaltung. Leitfaden der Ergonomie*. 4th revised edition, Landsberg 1991
Hahne, Fritz: *Zwischen den Stühlen*. Bad Münder 2, 1990
Moderne Klassiker. Möbel, die Geschichte machen. Publication of *Schöner Wohnen* magazine, 17th edition, Hamburg 1996
Pélegrin-Genel, Elisabeth: *Büro. Schönheit, Prestige, Phantasie*. Cologne 1996
Sembach, Klaus-Jürgen/Leuthäuser, Gabriele/Gössel, Peter: *Möbeldesign des 20. Jahrhunderts*. Cologne, no year
Wilkhahn. Dokumente der Gestaltung. Catalog for the exhibition *Wilkhahn. Sitzt. Dokumente der Gestaltung* 1985 in Essen and Hanover. 3rd extended edition with a smaller format, Bad Münder 1992
z. B. Stühle. Ein Streifzug durch die Kulturgeschichte des Sitzens. Vom Thron zum Chefsessel. Vom Baumstumpf zum Designprodukt. Vom Küchenstuhl zum Kunststoffobjekt. Vom Heiligen- zum Feuerstuhl. Catalog for the exhibition of the Deutsche Werkbund in cooperation with the Badische Kunstverein Karlsruhe and the Düsseldorf Art Museum. Ed. Michael Andritzky. Giessen 1982

The complete *FS* family today. It started in 1981 with eleven versions and now includes 40. The core piece, the real classic, is the model 211/8 (swivel chair with round low back and armrest). The most expensive version is the leather high backrest chair 220/11 with the square backrest contour that was added during the eighties.

The following page: At "home" also in the Far East: *FS* chairs in the lobby of Tokai Bank in Osaka.

Photo Credits
p. 11: Manufaktum, Marl; p. 18, 22, 40: *form*, Zeitschrift für Gestaltung, Frankfurt. All other images: Wilkhahn, Bad Münder, and Klaus Franck and Werner Sauer

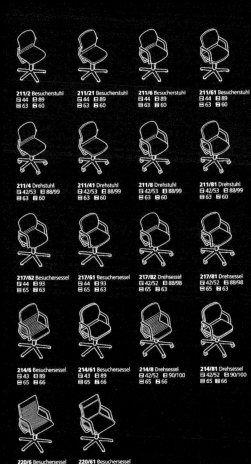

211/2 Besucherstuhl
44 / 89
63 / 60

211/21 Besucherstuhl
44 / 89
63 / 60

211/6 Besucherstuhl
44 / 89
63 / 60

211/61 Besucherstuhl
44 / 89
63 / 60

212/5 Freischwinger
44 / 85
56 / 61

212/51 Freischwinger
44 / 85
56 / 61

213/4 Drehstuhl
42/53 / 105/116
63 / 60

213/41 Drehstuhl
42/53 / 105/116
63 / 60

211/4 Drehstuhl
42/53 / 88/99
63 / 60

211/41 Drehstuhl
42/53 / 88/99
63 / 60

211/8 Drehstuhl
42/53 / 88/99
63 / 60

211/81 Drehstuhl
42/53 / 88/99
63 / 60

213/8 Drehstuhl
42/53 / 105/116
63 / 60

213/81 Drehstuhl
42/53 / 105/116
63 / 60

217/62 Besuchersessel
44 / 93
65 / 63

217/61 Besuchersessel
44 / 93
65 / 63

217/82 Drehsessel
42/52 / 88/98
65 / 63

217/81 Drehsessel
42/52 / 88/98
65 / 63

217/52 Freischwinger
42 / 84
60 / 62

217/51 Freischwinger
42 / 84
60 / 62

217/92 Drehsessel
42/52 / 110/120
65 / 63

217/91 Drehsessel
42/52 / 110/120
65 / 63

214/6 Besuchersessel
43 / 89
65 / 66

214/61 Besuchersessel
43 / 89
65 / 66

214/8 Drehsessel
42/52 / 90/100
65 / 66

214/81 Drehsessel
42/52 / 90/100
65 / 66

216/5 Freischwinger
44 / 85
60 / 66

216/51 Freischwinger
44 / 85
60 / 66

215/8 Drehsessel
42/52 / 108/118
65 / 63

215/81 Drehsessel
42/52 / 108/118
65 / 63

220/6 Besuchersessel
42 / 92
67 / 63

220/61 Besuchersessel
42 / 92
67 / 63

220/5 Freischwinger
40 / 85
63 / 62

220/51 Freischwinger
40 / 85
63 / 62

220/7 Besuchersessel
42 / 108
67 / 63

220/71 Besuchersessel
42 / 108
67 / 63

220/8 Drehsessel
42/52 / 92/102
67 / 63

220/81 Drehsessel
42/52 / 92/102
67 / 63

220/9 Drehsessel
42/52 / 108/118
67 / 63

220/91 Drehsessel
42/52 / 108/118
67 / 63

Wilkhahn
Eimbeckhausen
Landerfeld 8
D-31848 Bad Münder
Fon +49 (0) 50 42 999 - 0
Fax +49 (0) 50 42 999 - 245

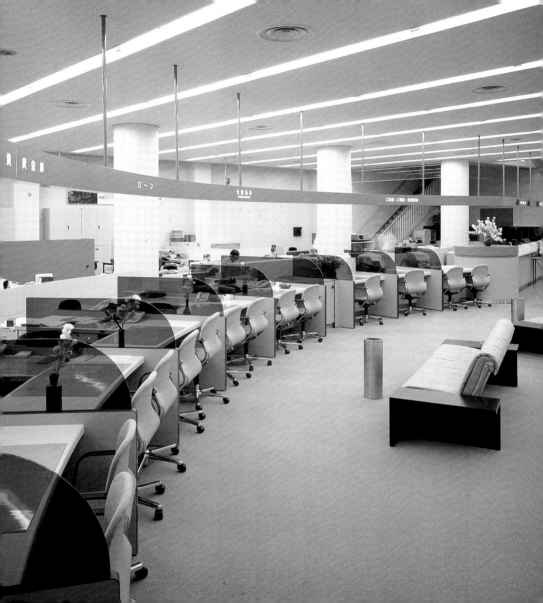

Service
If you would like to receive our catalog,
please contact us:

Verlag form.
Books & Magazines on design issues.

Telephone +49 (0) 69 94 33 25-0
Facsimile +49 (0) 69 94 33 25-25
e-Mail: form@form.de
http://WWW.form.de

Impressum
© 1998 Verlag form GmbH,
Frankfurt am Main
All rights reserved, especially those of
translation into other languages.

Translated into English by:
Katja Steiner and Bruce Almberg

Editor:
Volker Fischer

Editorial Department:
Anne Hamilton

Graphic Design:
Sarah Dorkenwald,
Absatz, Gesellschaft für
Kommunikations-Design,
Frankfurt am Main

Lithography:
Hans Altenkirch
Mediaproduktionen GmbH, Nieder-Olm

Print:
Franz Spiegel Buch GmbH, Ulm

Die Deutsche Bibliothek –
CIP-Einheitsaufnahme
The office swivel chair by Klaus Franck
and Werner Sauer / Elke
Trappschuh. [Transl. Into Engl. by:
Katja Steiner and Bruce Almberg.
Ed.: Volker Fischer]. –
Frankfurt am Main : Verl. Form, 1998
(Design classics)
Dt. Ausg. u.d.T.: Der Bürodrehstuhl von
Klaus Franck und Werner Sauer
ISBN 3-931317-74-9